Zen and the Magic of Photography

Wayne Rowe

Zen and the Magic
of Photography

Learning to See and to Be through Photography

rockynook

Wayne Rowe (wayne@waynerowephoto.com)

Editor: Gerhard Rossbach, Production Editor: Joan Dixon, Copyeditor: Cynthia Anderson
Layout and type: Cyrill Harnischmacher , Cover design: Helmut Kraus, www.exclam.de
Cover photos: Wayne Rowe, Printer: Friesens Corp.
Printed in Canada

ISBN 978-1-933952-54-3

1st Edition
© 2010 Wayne Rowe
Rocky Nook, Inc.
26 West Mission Street, Ste 3
Santa Barbara, CA 93111-2432
www.rockynook.com

Library of Congress Cataloging-in-Publication Data

Rowe, Wayne.
Zen and the magic of photography :
learning to see and to be through photography / by Wayne Rowe. -- 1st ed.
p. cm.
Includes bibliographical references.
ISBN 978-1-933952-54-3 (alk. paper)
1. Photography--Psychological aspects. 2. Composition (Photography) I. Title.
TR183.R69 2010
770.1--dc22

2009048812

Distributed by O'Reilly Media · 1005 Gravenstein Highway North · Sebastopol, CA 95472

Unless otherwise noted, all photographs and illustrations are by the author.

This book is printed on acid-free paper.

*To Yvone, my wife, whose irrepressible joie de vivre
profoundly touches and influences my life*

Acknowledgments

I would like to express my appreciation to the following people:

Rodney Azarmi, Art Suwansang, and Richard Wong for their support for this book from its beginning; Walter Wells for his incisive analysis of the manuscript and for his constant push to get this book published; Michael Shulman, Director of Publishing, Broadcast and Film, Magnum Photos; Ronald Pledge of Contact Press Images; Jessica Licciardello of George Steinmetz Photography; Alex and Victoria Haas of the Ernst Haas Studio in New York; Martha Winterhalter, Publisher, American Cinematographer Magazine; Dave McCall of the British Film Institute; Professor Leo Braudy of the University of Southern California; Arthur Rothstein and the Library of Congress; Jeff Burak, Director of Business Development, LIFE.com; Katherine Tannian and Joelle Sedlmeyer of Getty Images; Regina Feiler of Time Life; Rich Kallan and Glenn Rand for introducing me to Rocky Nook; Jimi DeRouen, Joan Dixon, and the design staff at Rocky Nook; and most importantly, Gerhard Rossbach, Publisher of Rocky Nook, for believing in my manuscript and giving it a life of its own.

To my brother Dennis for his portrait of me taken in Italy with his trusty iPhone.

To Yvone, my wife, for all that she is and has done for me over the years to make this book a reality.

Wayne Rowe
November 2009
Los Angeles

Table of Contents

Opening Oneself to the Light:
Some Personal Moments of Experiencing Zen and Satori through Photography

Introduction

Photography is a universal language spoken by people throughout the world. The problem is that few of us speak this language well. Although people take billions of photographs each year, most of us cannot tell the difference between a good and bad photo. What are the characteristics of a good photograph? How can you make visible the invisible elements it may contain? How can you improve the quality of your own photography? How can you become a better photographer?

Becoming a better photographer first means mastering the principles of camera operation, lighting, and composition. To add to your repertoire of technical photographic skills, you can attend workshops and seminars, enroll in college photography courses, study technical photography books, and get hands-on practical experience. Whether you use a pinhole camera or a state-of-the-art digital single lens reflex (DSLR) camera, the fundamental principles of camera operation are the same. You need to understand and deal with the concepts of shutter speed, f/stop, and ISO. However, mastery of camera operation and photo equipment alone does not guarantee good photographs.

Becoming a better photographer also means developing your visual awareness, sensitivity, and intuition. Your knowledge of how to operate a camera must be combined with your knowledge of *how to see*. The hands-on skill needed to record an image is one thing; selecting what to record is another that depends upon your state of awareness, your connection with *real moments* and your connection with the Now. Photographer Joel Meyerowitz put it best: "Photography records what awareness observes".

Zen and the Magic of Photography will help you improve your visual awareness and the quality of your photography by helping you discover and experience the points of intersection and merging between photography and Zen, between the camera and real moments, between seeing and being—the point at which all such distinctions no longer exist; the point at which photography and Zen are one. This is the point where we discover and create our best photographic images.

Part I of the book focuses on the nature of the photograph and the connections between photography and Zen. It gives you a way to discover, create, and capture the images around you—a way to establish an intuitive contact with reality. Part I also shows you how to make the "invisible visible" through the art of photographic analysis.

Part II extends the connections between photography and Zen, between seeing and being, to the photographic image in all its forms—from the still photograph to the motion picture—and discusses some concepts common to all forms of the photographic image.

Part III uses photographic examples to illustrate the point of merging between photography and Zen as experienced by the author.

Zen and the Magic of Photography is offered as a tribute to photography. I have personally experienced the magic of photography and was motivated to share what I have learned with others. During the process of writing this book, I revisited the work of many different photographers, among them Manuel Alvarez Bravo, Ernst Haas, Joel Meyerowitz, Sebastião Salgado, Dennis Stock, and Minor White. Their images or thoughts about photography appear as support for my own approach to visual awareness. I include them as a way of pointing out the fact that we photographers share similar feelings and experiences when we discover, create, and capture images.

Experiencing the relationship, the interaction, between Zen and photography has given me an orientation to the world, a visual awareness, a way to get more out of life, and a way to taste and savor the reality of the moment—the Now. It has taught me *how to see*—and, ultimately, through seeing, *how to be*. I trust that it can do the same for you.

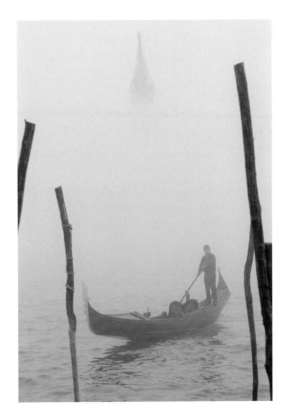

▲ *Gondolier and Church Steeple. Venice, Italy*

Experiencing Zen through Photography and Photography through Zen

The more you actively look, the more the action will become intuitive and natural, subconscious and effortless. With practice, your eye will be intuitively and subconsciously drawn to the light, and the light will be drawn to your eye.
Wayne Rowe

"Bow, arrow, goal and ego, all melt into one another, so that I can no longer separate them. And even the need to separate has gone. For as soon as I take the bow and shoot, everything becomes so clear and straightforward and so ridiculously simple...."

Eugen Herrigel, Zen in the Art of Archery

"Without satori there is no Zen. Zen and satori are synonymous."

D. T. Suzuki, Zen and Japanese Culture

The Essence of Zen and Satori

During the course of my college studies, I came across a Zen parable about a man who encounters a tiger in a field. The man flees, and in his efforts to escape the tiger, he lowers himself by a wild vine down the face of a cliff. Trembling, he suddenly realizes that the tiger he is fleeing from is directly above him and that another tiger is waiting below. His life now depends upon the strength of the vine. If this situation were not bad enough, two mice, one black and one white, begin to gnaw at the vine. The story ends as the man sees a luscious strawberry growing near him on the precipice. Grasping the vine with one hand, he plucks the strawberry with the other. "How sweet it tasted!"

After reading this as a young student, I was certain that Zen was the philosophy for me. Little did I realize the degree of enlightenment required to reach this state! In fact, I was never *consciously* able to reach it. In spite of all the reading I did and the vows I made, the enjoyment of that strawberry eluded me. And then, as I got deeper into photography, I began to experience glimpses of what Zen was all about. One day it suddenly occurred to me that I had already experienced it—*unknowingly*—as a photographer! It was through the art of photography that I had plucked the strawberry and tasted its sweetness

in a sustained and repeatable way—without even trying. And, at the same time, I realized that it was through the experience of Zen and satori that I was able to discover, create, and capture my best photographs. Photography and Zen had merged. They were one. I was experiencing Zen through photography and photography through Zen.

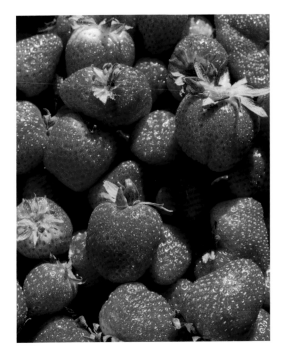

▲ *"How Sweet it Tasted!"*

What is Zen? What is Satori?

According to D. T. Suzuki, the legendary interpreter of Zen for the Western mind, "Zen discipline consists in attaining enlightenment (or satori)... Satori finds a meaning hitherto hidden in our daily concrete particular experiences...The meaning thus revealed is in being itself, in becoming itself, in living itself...in the 'isness' of a thing". This definition of Zen is what appealed to me in college: the idea that life is here and now and not something that we should postpone to a future date. Zen and satori represent the "in the moment" plucking and tasting of the strawberry in front of us.

Zen, Haiku, and Photography

The haiku, a short Japanese poem consisting of 17 syllables, is defined by D.T. Suzuki as "the spirit of Zen" and "a significant intuition into Reality". R. H. Blyth defined the haiku as "the expression of a temporary enlightenment, in which we see into the life of things". Perhaps the most famous haiku is by the Japanese poet Basho:

> *The old pond.*
> *A frog jumps in—*
> *Plop!*

Through his intuition or feeling, Basho was into the moment, into its isness, its "suchness", its spiritual rhythm. He was into Reality and was experiencing Zen and satori. Similarly, Vincent Van Gogh, possessed by the light and color of Provence, discovered the isness, the nowness, and the suchness of things: wind-whipped cypresses, wheat fields, a flowering almond tree branch. With the searing sun of southern France burning images into his brain, Van Gogh threw himself headlong into capturing the images and experienced significant intuitions into Reality as he created oil-on-canvas haikus: "It's the only time I

feel I am alive", he wrote to his brother Theo. Like Basho, Van Gogh experienced the spirit of Zen and satori.

By the same token, photographer Edward Weston created silver halide haikus: "To see the Thing Itself is essential: the Quintessence revealed direct...". Like Basho and Van Gogh, Weston had significant intuitions into Reality. The photographer, like the poet and the painter and any other artist, can provoke satori or enlightenment and record it in his or her creation.

Photographer Dennis Stock illustrated eight haikus written by Basho. In each of them, there is an equivalence between Stock's visual haiku and Basho's verbal haiku. In one of these pairs, a lone brown-orange leaf hangs on a branch backlit by a glowing autumn sun coupled with Basho's words: "This autumn why do I feel so old? Years roll by like clouds, swift as swallows fly!"

This pairing of a visual and a verbal haiku reminds me of William Shakespeare's Sonnet No. 73:

That time of year thou mayst in me behold
When yellow leaves, or none, or few, do hang
Upon those boughs which shake against the cold,
Bare ruined choirs, where late the sweet birds sang.
In me thou see'st the twilight of such day
As after sunset fadeth in the west;
Which by and by black night doth take away,
Death's second self, that seals up all in rest.
In me thou see'st the glowing of such fire,
That on the ashes of his youth doth lie,
As the death-bed, whereon it must expire,
Consum'd with that which it was nourish'd by.
This thou perceiv'st, which makes thy love
more strong,
To love that well, which thou must leave
ere long.

What we see expressed here are three moments of satori on the subject of growing old. It doesn't matter that the forms used to express these moments are different: the haiku, the photograph, and the sonnet. What they share is their total absorption with the Now and the externalization of intuitive feelings.

One summer in southern France, as the mistral wind blew outside the house, I experienced feelings comparable to Basho's and expressed them in the following haiku:

A summer mistral:
 Sun and shadows dance;
 A door slams; the cat hisses.

Another day there, in the silence of a summer afternoon, I became aware of two distinct sounds: a rain-like murmur created by a myriad of yellow pollen bits falling from the tiny flowers of the vines covering the house; and the buzz of numberless but invisible bees at work gathering the pollen. The following haiku came to mind:

Summer ivy wall:
 Hum of the universe;
 Golden rain on a roof.

French writer, philosopher, and language expert Roland Barthes recognized the linkage between haiku and photography. Accordingly, in his book *Camera Lucida*, he undertook to define the essence of photography. He described the photographs that "animated" him and that he in turn "animated" as consisting of two co-present elements: *studium* and *punctum*. According to Barthes, studium is an extension of our field of knowledge and cultural information. It is by studium that we take an interest in photos that refer to a classical body of cultural information: photos that educate, signify, represent, inform, and reveal the photographer's intentions.

The second element, punctum, as Barthes said, "will break (or punctuate) the studium… the photographs I am speaking of are in effect punctuated, sometimes even speckled with these sensitive points; precisely, these marks, these wounds, are so many points". According to Barthes, punctum rises out of the scene, seeks out the viewer, disturbs the studium, wounds, cuts, pricks, and stings the viewer. Furthermore, punctum has the power to expand and to provoke satori. The trigger that provokes satori, "a tiny shock", is usually found in a detail. In Barthes' eyes, this brings certain photographs very close to the haiku.

Take a look at the photograph of James Dean by Dennis Stock, and with Roland Barthes' ideas about

▶ *James Dean. Times Square, New York, 1955.*
© Dennis Stock/Magnum Photos

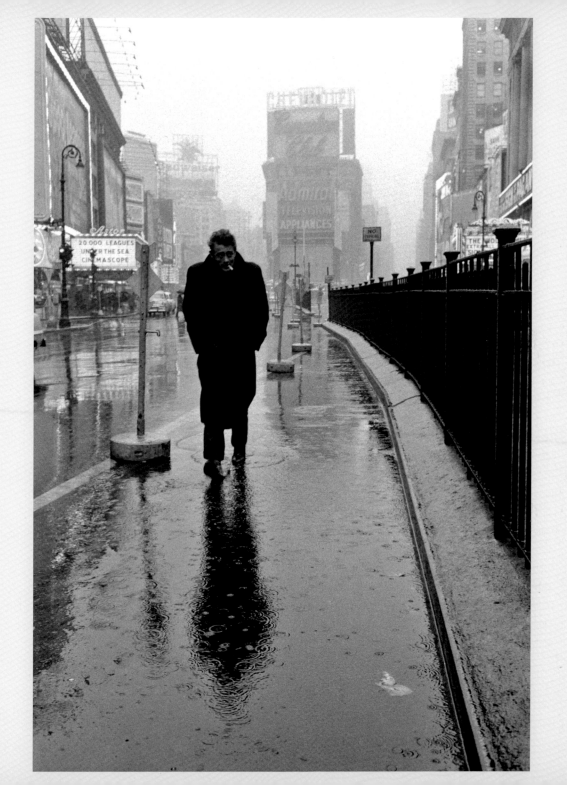

photography in mind, "allow the detail to rise of its own accord into affective consciousness". Then, write down your personal reactions to the photograph. Write down anything that enters into your affective consciousness. If this photo animates you, you might further consider Barthes' ideas and identify the studium and the punctum: What constitutes the studium? What constitutes the punctum? Does anything provoke satori? After you finish your own analysis, consider my interpretation below. Then follow the same procedure for the next photograph by Sebastião Salgado. Both of these photographs are iconic images and cultural points of reference.

This photograph by Dennis Stock has an existential mood and a mysterious romantic poetry. It represents a perfect interaction between the photographer, the subject, the setting, and the moment. It is, in fact, a silver halide haiku. It records satori experienced by the photographer and his subject, and it provokes satori in the viewer as well. One point of punctuation, of punctum, in this photograph—one thing that disturbs, that rises out of the scene, that seeks out the viewer, that provokes satori—is the physical attitude of James Dean: hunched and huddled, hands in pockets, cigarette in the corner of his mouth, a lone dark figure rising out of a deserted urban landscape under the rain. He is an alienated, Hamlet-like presence who has resolved the question of whether "to be or not to be" by choosing *to be*— to be intensely aware and alive in this real moment, to feel the isness of the moment, to be in the Now, to have a significant intuition into Reality.

Study his nonverbal body attitude: the tilt of his bare head under the rain, his hunched shoulders, the intense and focused concentration in his eyes, the angle of the cigarette. All of these elements conjoin to convey the feeling of his absorption in the Moment, in the Now, in being itself, in becoming itself, in the solitary Reality of that instant. It is, as James Dean himself would have called it, a "real moment", an instant of captured reality that pulls us into the photo and animates us.

Compositionally, the placement of the subject above and to the left of center gives an asymmetrical balance to the photograph. Dean's head is placed at a point of intersection approximately one-third down from the top and one-third from the left side of the photograph. This is known as a Golden Mean point, and the eye is immediately drawn to it. In addition, the darker tones of the man contrast strongly with the lighter background. Behind Dean and to our left is a theater with a small crowd huddled under the

marquee, several cars, and a passerby hurrying under an umbrella. Strangely, this suggestion of public life does not alter the loneliness and isolation of the dark figure. In fact, the crowd serves as a vivid contrast to it.

To the far right are more theaters representing, perhaps, places of dreams and illusions. The crowded main street on the far left represents the ever-moving stream of conventional life. The path that the actor has taken signifies an unconventional diversion from the mainstream—the choice of a rebellious nonconformist. The cement markers along that diversion frame him perfectly and give a loose order and structure to that part of the photograph. Within that structure the subject is free to improvise, to interpret, and to give feeling and reality to the moment—much as an actor upon a stage.

To the viewer's immediate right is the ordered and patterned repetition of the solid iron fence that represents the material world as well as a barrier, separating dream from reality. With its rhythmically placed pattern of perforations, it brings to mind a strip of film where photographers and actors are able to externalize and to give concrete form to their inner dreams and visions—much as Dennis Stock and James Dean did here. Its diminishing perspective

adds to the illusion of depth already created by the high horizon line and the soft, foggy impressionism of the background buildings. Furthermore, if we compare the actual image with its reflections in the wet pavement, we see how material reality contrasts once again with illusory dream.

A photograph is a reflection of light. What we see on the pavement in front of James Dean is a reflection of a reflection—the negative of a positive. Compositionally, the positive area above the reflection occupies two-thirds of the entire frame, while the area of the reflection and the space below it account for one-third of the entire frame. This perfect division of visual elements embodies the harmony of the Golden Mean (two-thirds is to one-third as one is to two-thirds). It serves to asymmetrically balance the photo along the lines of its contrasting elements: positive versus negative, white versus black, reality versus dream, conventional versus unconventional, external versus internal, whole versus part.

Furthermore, and most importantly, we discover additional points of punctuation that surround the image reflected in the wet pavement. These erratic, vibrating, overlapping rings of punctum literally disturb, wound, and break the studium of the photograph, animating the viewer. They break and

wound both the reflected image of the subject and the emotions of the viewer. Visually, they echo Marlon Brando's observation that Dean projected "a subtle energy and an intangible injured quality". Finally, the reflected image of James Dean leaves us with a fragmented, opaque representation of an enigmatic figure whose mystery was captured in the magic of that real moment.

Now that you have read my detailed and very personal interpretation of this image, examine the image again and compare my interpretation to your own initial analysis. Consider other possibilities. What is Dean looking at off-camera? What is he doing there? Was this a moment of improvisation, or did Dennis Stock have him purposely pose for this shot? If you knew the answers to these questions, would that make any difference in your analysis? The possibilities of interpretation are endless. This is the hallmark of poetic images, of images that go beyond studium, of images with punctum: they have the power to expand and to provoke satori. By opening ourselves to the image, by allowing the detail to rise of its own accord into affective consciousness, and by linking vision and feeling, we can make the invisible visible. We can extend the boundaries of our visual awareness through the medium of photography. We can learn *to see* and *to be* through photography.

In order for a photograph to touch him, Roland Barthes' method was "to say nothing, to shut my eyes, to allow the detail to rise of its own accord into affective consciousness". Let's apply Barthes' method to another iconic photo, this time by Sebastião Salgado. Say nothing. Listen. Let the image speak. Wait to "hear the light". What you find in the photograph depends upon what your own sensitivity, experience, field of knowledge, and cultural information bring to it. Study the image carefully and record your impressions. After you make your own analysis, consider the one I made by opening myself to the photo and letting it speak to me. Using Barthes' technique, I drew this interpretation from my own educational background and field of experience.

When I think of photographer Sebastião Salgado, what comes to mind are the words "humanitarian", "humanist", and "concerned photographer", as well as the I-Thou attitude of Martin Buber. The only other photographers whose names I associate with similar thoughts and feelings are James Nachtwey and W. Eugene Smith. This is a very rarified group of photographers.

▶ *Serra Pelada Gold Mine. Serra Pelada, Brazil, 1986. © Sebastião Salgado/Amazonas Images/ (Contact Press Images)*

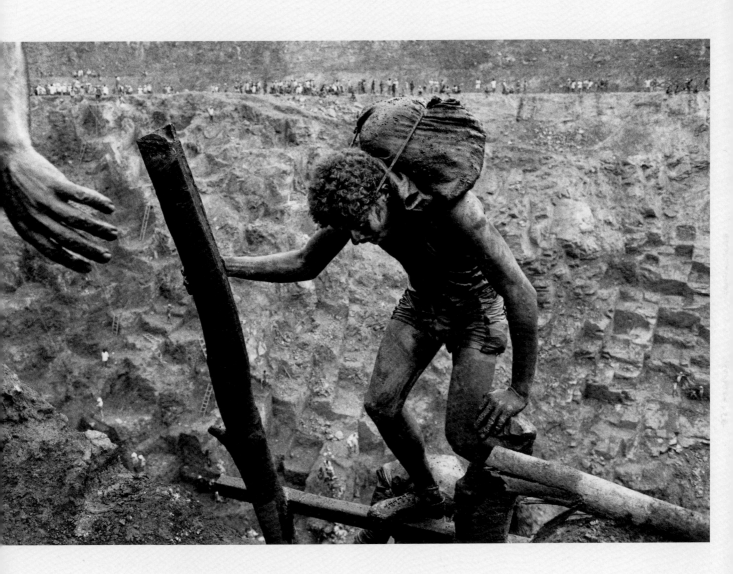

Sebastião Salgado was a student of economics who completed his Ph.D. course work in Paris, France and then decided to abandon academia for photography. He chose the power of the image over the power of the word to show the plight of the poor, the disadvantaged, the despised, and the abandoned people of the world. His photographs directly confront injustice, inhumanity, and horror with boundless compassion and empathy. His innate respect for his subjects is in keeping with Martin Buber's I-Thou approach towards the world. In Buber's terms, Salgado does not "experience" his subjects (I-He, I-She, or I-It), but rather "stands in relation" to them in total empathy (I-Thou). He feels their pain. He suffers with them. He captures what he sees and feels. He and his camera and his subjects become one. Through his photographs, we become one with his subjects. We recognize that we are made of the same substance.

The studium in this photograph shows us a giant gold mine in Serra Pelada, Brazil. Mud-soaked manual laborers swarm like ants in a destroyed anthill, carrying their heavy sacks of gold-laced mud to the surface on primitive wooden ladders. Within the pit, we see a hierarchy: mud-covered workers and supervisors in white hats and shirts. The super-visors appear on the opposite rim of the pit near the top of the image, in vivid contrast to the workers. In the middle of the photo, we see quarry-like, stepped carvings and cuttings into the rock walls that resemble ravaged and pillaged pyramids in Egypt.

At this point, the studium begins to merge with the punctum, and I follow Barthes' advice to "allow the detail to rise of its own accord" into my affective consciousness. I see punctum speckled throughout the photograph. My eye is drawn to the sharply focused central figure; its rich, dark tones and shadings contrast with the uniformly gray and low-contrast background. One detail that catches my eye is the rope, which connects the subject's head with the heavy sack on his neck and shoulders. I feel the pressure against his forehead and the weight of the mud-filled sack on his body. He strains with head down, doing everything he can to avoid falling backward into the pit. The muscles of his body, especially his left arm and leg, form other points of punctuation that move, touch, and disturb me as a fellow human being.

Next to his slippery, muddy shoe, I see another sack and a small section of rope that I know is attached to the sack and forehead of another worker a step away. The muddy right hand of the central figure

seems to fit into the chiseled surface of the ladder, although the broken branch in the lower right corner is a detail that reminds me of the ladder's fragility and the low value put on the lives of the workers. How long can a man last doing this type of labor?

And then out of the left corner of the image I see a hand, a point of punctuation, extended in the direction of the worker on the ladder: a gray-black hand edged in white light that completes and transforms this photo into an icon. Light that transforms the darkness. Suddenly, my mind is transported to the ceiling of the Sistine Chapel in Rome and to Michaelangelo's fresco *The Creation of Adam*: the hand/finger of God reaching out to the hand/finger of Adam. I am moved by the similarity between the gestures. God gives life to Adam, and one Serra Pelada worker offers life to another. In this photograph, Sebastião Salgado captured a moment of truth and humanity—a moment where he, the two workers, and the mud pit are one, a moment of satori. In the middle of this brutal reality, he recorded a moment where spiritual values outweigh the value of gold.

The art of photographic interpretation is as creative as the art of discovering, creating, capturing, and editing images. It requires you to open yourself to the image, the light, the details, and to your feelings.

You need to link vision and feeling. After doing your own analysis of Sebastião Salgado's photograph and comparing it with mine, you will most likely notice differences in what we each saw and felt. This is perfectly normal since everyone brings something different to the act of analysis. In fact, photographic analysis may be compared to the old Spanish travelers' inns of the 17th century. There is a proverb that says, "Life is like a Spanish inn. You find there what you bring to it". Since little food was available, inns had the reputation of cooking and serving only what you brought along. If you brought more, you found more. If you brought nothing, you found nothing. And so it is with the art of photographic interpretation: what you find in an image is what you uniquely bring to it.

As a way of helping you to make visible the invisible elements of a photograph and to unlock your own inner resources and knowledge, I have urged you to link vision and feeling, to open yourself to light and feeling, and to "allow the detail to rise of its own accord into affective consciousness", as Roland Barthes expressed it. This will help you to discover the studium and the punctum in any photographic image. Most importantly, I urge you to make learning a lifelong pursuit. This will open up possibilities for

richer photographic interpretation through associations with art, poetry, music, literature, religion, history, philosophy, psychology, and all sorts of cultural symbols and icons. This approach to the art of photographic interpretation complements the Zen orientation of this book.

You might, however, be wondering whether the lifelong pursuit of learning will make you a better photographer. I believe that it will. It will be reflected in the depth and quality of your photography. Witness the lives and philosophies of photographers Ansel Adams, Lucien Clergue, Ernst Haas, Edward Weston, and Minor White to name just a few. Ansel Adams, for example, wanted to become a concert pianist but the attraction of photography was stronger. Yet the artistic influence of music never left him. Photo critic John Szarkowski, in speaking of the relationship between the gray scale of photographic tones in photography and the chord structure in music, revealed that Adams would "talk about chords of tone. He insisted that the photograph be, seem to be, tonally complete, tonally fulfilled, resolved, and that it could have no holes in it".

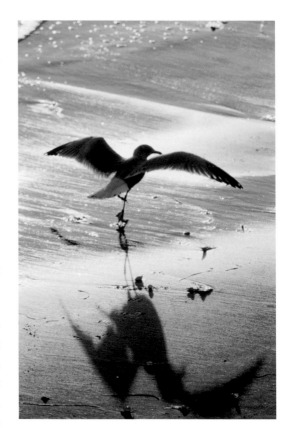

▲ *Seagull in Sunset. Malibu, California*

Photography and the Creative Mind

Minor White believed that the mind of a photographer when looking for and creating photos was a blank. According to White, the creative mind of a photographer is like a piece of unexposed film. It contains no preformed images but is always active, open, receptive, and ready to receive and record an image. It is a special kind of blank. It is the same state of mind experienced by Edward Weston: "I start with no preconceived idea—discovery excites me to focus—then rediscovery through the lens…"

In a letter to his brother Theo, Vincent Van Gogh referred to this same creative state of mind when he spoke of having a "terrible lucidity at moments when nature is so beautiful". He confessed that, at moments like this, he was not conscious of himself anymore and that the pictures came to him as in a dream: "I can only *let myself go* these days that are free from wind, especially as I think the work is getting rather better than the last sent you".

I believe that photographer Ernst Haas described the workings of this creative state of mind most poetically in his video *To Dream With Open Eyes*:

"There is another way of digestion, which has nothing to do with our consciousness, it's kind of an unconscious way to digest. And that's dreaming. That means you go into a state almost like an aware kind of sleep, which means you're all free, just let it be, let it become, and with tremendous compassion towards everything—maybe human beings, or nature, or objects—you incorporate. It's almost like a….in Buddhism, you would say incarnation. You become things, you become an atmosphere. And if you become it, which means you incorporate it within you, you can also give it back. You can put this feeling into a picture. A painter can do it. And a musician can do it and I think a photographer can do that too. And that I would call the dreaming with open eyes."

Zen and the Empty Mind

When thinking about a photographer's blank state of mind when looking for images, I am reminded of the Zen concept of the "empty mind"—a mind that is awake, but fixed nowhere.

The Zen doctrine of *mushin*, or "no-mind-ness", is embodied in the teaching of swordsmanship. In order to survive in battle, the samurai swordsman needs a blank and empty mind—a mind fixed nowhere and on nothing. The samurai's sword must be totally guided by intuition and not in any way by reason. In the heat of battle, there is no time to think. If you pause to think, you will surely be defeated. Takuan Soho, in his book *The Unfettered Mind*, said that for the samurai warrior, "the No-Mind is the same as the Right Mind". The no-mind is empty. It contains nothing. It is placed nowhere. It is everywhere, like reflections of the moon in water. When there is nothing in the mind, it can also be called "no-mind-no thought".

Similarly, Eugen Herrigel, in his classic book *Zen in the Art of Archery*, described the relationship between the mind of the archer and the empty mind. He observed that the "right presence of mind" involves an empty and open state of mind with no definite plans, thoughts, desires, expectations, purposes, or ego-involvement—but where all is possible. According to Herrigel, "This means that the mind or spirit is present everywhere, because it is nowhere attached to any particular place". His description of the state of mind of the archer practicing his art echoes Minor White's description of the blank and empty mind of the photographer while looking for photos and Takuan Soho's no-mind-no-thought mental state of the samurai warrior in action.

▲ *Trompe L'oeil. Venice, Italy*

The Role of Intuition and Feeling in Photography

At this point, we have established and accepted a basic connection between Zen and the art of photography. What other connections might there be? Can Zen explain why the photographer releases the shutter at one particular moment rather than at another? Can Zen explain what subconscious impulses activate the trigger finger?

Many photographers, including myself, believe in the power of intuition or feeling in photography. Ansel Adams' thoughts on the subject can serve as a guide:

" I always encourage students to photograph everything they see and respond to emotionally... I have made thousands of photographs of the natural scene, but only those visualizations that were most intensely felt at the moment of exposure have survived the inevitable winnowing of time."

Similarly, in the book *Masters of Light*, Conrad Hall had this to say about the role of feeling in cinematography:

"You've got to be able to do it the way you want to and know why it is that you're doing it. And at least if you don't know intellectually, you know emotionally that it's right. It feels right to you."

Is there a link between the blank and empty mind and intuition/feeling in photography? Curt John Ducasse, in his book *The Philosophy of Art*, provided an answer to this question. He believed that whether you are searching for photographic images, looking at Van Gogh's *Irises*, or listening to the voice of Pavarotti, you should inwardly "clear the ground" of antecedent feelings (empty the mind), concentrate your attention on those images or sounds in front of you, throw yourself open "to the advent of feeling", and look or listen with your "capacity for feeling".

Looking with the capacity for feeling, that is, *linking vision and feeling*, is exactly what photographer Joel Meyerowitz does. When looking for images, he keeps himself open to feeling:

"You walk along and you're open. Hopefully, you're open...When I walk out with the camera, I'm ready for anything; that's the Zen swordsman's motto: expect nothing, be prepared for everything.
If your feelings have gotten to you, at that moment, then maybe what you're seeing will get into the photograph."

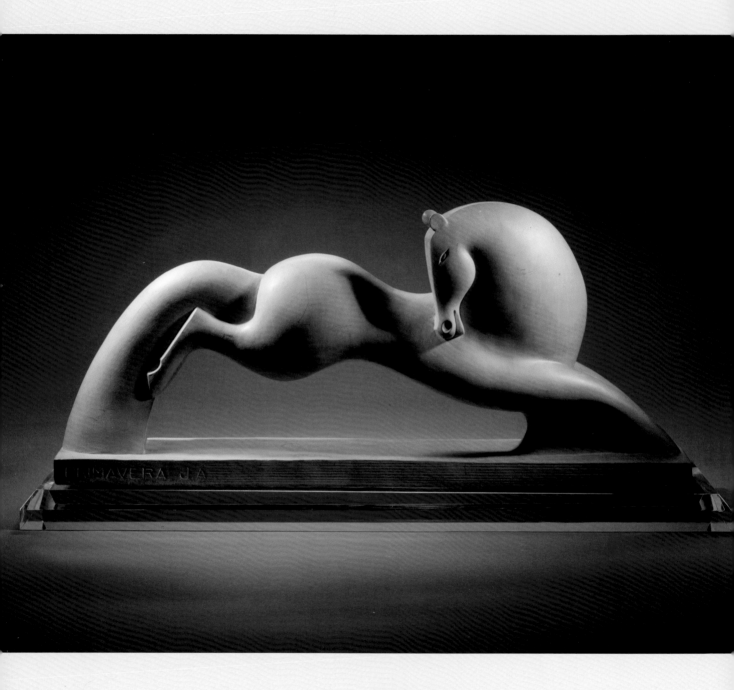

At this point in our investigation, the role played by intuition and feeling in photography becomes clear and emphatic: when looking for photographs, empty your mind, throw yourself open to the advent of feeling, and let yourself be guided by your feelings. When searching for images, open yourself to the light, and open yourself to the images around you. Follow your intuition, believe in your feelings, and release the shutter when the image in the viewfinder feels right, when the image "sings", when you can "hear the light".

"Hearing the light" is a phenomenon that occurs on an intuitive level when you feel that the photographic image is right and that the moment has come to record it. This phenomenon may be experienced on location or in the studio. For example, when working in the studio with electronic flash, I continuously adjust and readjust my modeling lights and check the effects on the subject through the ground glass of the camera. Invariably, a moment arrives when everything feels right; when the image sings. I hear the light and then proceed to record the image.

It took time, patience, and much experimentation to finesse the light to the point shown in my photo "Art Deco Horse". Even the shadow areas were carefully shaped and controlled by placing pieces of black aluminum foil in the path of the light to achieve the desired effect. How did I know when the lighting was finished? What told me to finally record the image? I knew this lighting was at last right—something about it *felt* right—and then, upon closer inspection of the details, I saw the teardrop-shaped shadow (a symbol of speed) appear on the body of the horse. Punctum is "very often a detail". A point of punctuation, the *punctum*, had risen out of the scene, broken the studium, and provoked satori in me. I savored an extraordinary moment. The Polaroid I took to check the electronic flash lighting literally "sang" to me. It looked right, it felt right, and I knew the time had come to record the image.

◀ *Art Deco Horse. Los Angeles*

The Role of Intuition and Feeling in Zen

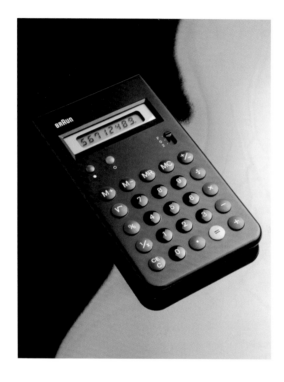

▲ *Braun Calculator. Studio shot, Los Angeles*

Do not kill the fly:
See how it wrings its hands;
See how it wrings its feet!
Issa

In my search to see what role (if any) is played by intuition or feeling in the Zen experience, I discovered D. T. Suzuki's belief that artistic creation can only come from intuition or feeling—feeling "directly and im-mediately rising from the isness of things, unhampered by senses and intellect". Once again, we find a connection between Zen and photography. It becomes clear that whenever you are dealing with light (artificial or natural) you must empty your mind, open yourself to the advent of feeling, and look with your capacity to feel. Be aware of the light, feel the light, and you will then hear the light. It is true that your photos must sing to be good.

Jacques Prevert, the French poet, captured the magic of this moment of satori in his poem "To Make the Portrait of a Bird":

First, paint a cage
with an open door
next paint
something pretty
something simple
something useful
for the bird
then place the canvas against a tree
in a garden
in the woods
or in a forest
hide behind the tree
without saying anything
without moving...
Sometimes the bird arrives quickly
but he may as well take years
before deciding to show up
Don't be discouraged
Wait
Wait if you must for years
the speed or the slowness of the arrival
of the bird having nothing to do
with the eventual success of the painting

When the bird arrives
if he arrives
observe the deepest silence
wait until the bird has entered the cage
and when he has
gently close the door with the paintbrush
then
erase one by one all the bars
being careful not to touch any of the feathers of the bird
Paint next the portrait of the tree
choosing the best of its branches
for the bird
paint also the green foliage and the cool of the wind
the dust of the sun
and the sound of insects in the grass in the heat of summer
and then wait until the bird decides to sing
If the bird does not sing
that's a bad sign
a sign that the picture is bad
but if he sings that's a good sign
a sign that you may sign
so, you gently pull
one of the feathers of the bird
and you write your name in a corner of the picture.

Translated from the French by Yvone Lenard
Copyright © Yvone Lenard 1990

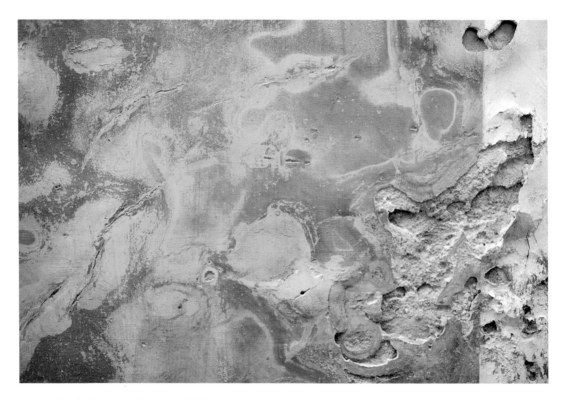

▲ *Souleiado Museum Courtyard Wall #1.*
Tarascon, France: The First Composition

Let me pull together all of the ideas discussed to this point and share a photographic experience—a moment of satori—that illustrates what I've been talking about. Recently, my wife and I visited the Souleiado Museum in the town of Tarascon in southern France. It is housed in a 16th century former monastery. The Souleiado company is famous for its colorful, beautifully bordered Provençal print

fabrics. We had just entered a small, open courtyard and were talking to the lady in charge. I was attracted to the worn finish on the Anduze flowerpots and to the weathered walls surrounding the courtyard. The peeling and smeared layers of colorful Provencal paints on these old walls caught my eye. I recognized a similarity between the fabrics we had just seen and the random abstract patterns made by the remnants of stucco and paint on the walls. One area especially caught my eye because of its white-bordered effect. My first photo, a wide-angle view, looked like a large piece of fabric with a white border. For the second shot, I moved in for a vertical close-up of the pattern and white border.

Sometime during composing and taking the second image, I saw another image. Among my first thoughts: a skull; the horror of war; a ripped poster of a horrified woman taken by Walker Evans. Finally, I was reminded of an iconic painting titled *The Scream* by Edvard Munch. I moved in even closer and took the third and final shot. It was a process of discovery—discovery of an invisible image made visible through the process of seeing, the process of finding the punctum, and achieving satori.

This is what happens when you are open to the light, open to images, and actively looking for images with your capacity for feeling. This is the creative

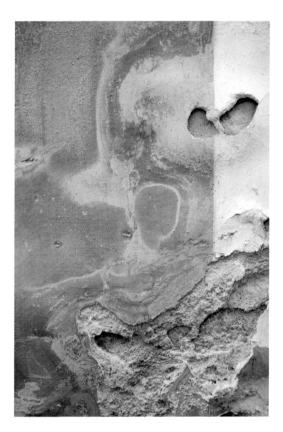

▲ *Souleiado Museum Courtyard Wall #2. Tarascon, France: Moving in closer for a vertical version of the composition*

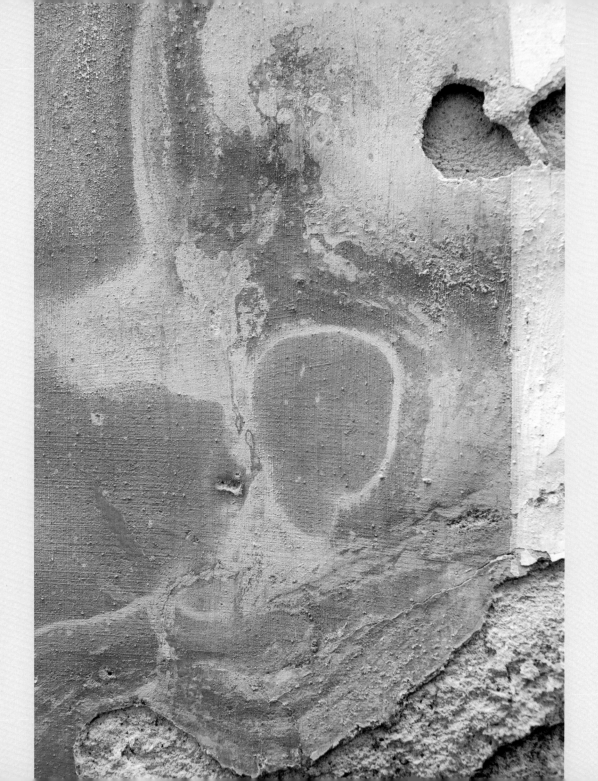

process in action; the finding and shaping of an image. This is the state Ernst Haas described when he said "...you're all free, just let it be, let it become... you incorporate. You become things, you become an atmosphere". I was in this open, active, intent, and searching state of mind when I took the three photographs at the Souleiado Museum. What you see in these images is the merging of photography and Zen, of seeing and being, of the camera and real moments. In other words, what you see is the result of my having achieved satori. What you see is what this book is all about. Study these photographs and see what you discover within each of the compositions.

At the beginning of this inquiry we sought to understand the state of awareness, involvement, and satisfaction one can feel through the art of photography—the sense that life is here and now, and that we are one with it—feelings of discovery, joy, and enlightenment. More specifically, we sought to reveal possible connections between Zen and the art of photography. As a result of our exploration, it has become clear that one may experience Zen through photography and photography through Zen. This occurs when seeing and being, when the

camera and real moments, when photography and Zen merge—when all such distinctions no longer exist. These are moments of heightened awareness when we discover, create, and capture our best photographic haikus. These are moments when we experience satori.

There are, of course, many other roads to satori. Herrigel experienced it through archery, Basho through haiku, Van Gogh through painting, James Dean and Marlon Brando through acting, and Frank Sinatra and Billie Holiday through singing. Each of these people participated in the creative process and in the creative experience. Each of them had significant intuitions into reality. Each of them experienced the Now—what James Dean called "real moments". As a teacher, I have shared my creative experiences and my passion for photography with my students in the belief that photography offers a way to improve awareness of the world around us, the quality of our lives, the ability to get more out of life—and at best, to experience satori.

Yet I knew I had to find a way to help students experience the creative process; to help them experience satori. I had to find a way to put the relationships and concepts we have discussed into action. I believe that part of the answer lies in the philosophy

◀ *Souleiado Museum Courtyard Wall #3.*
Tarascon, France: Finding the Punctum—The Final Close-up Composition

of Martin Buber. In his book, *I and Thou*, Buber divides the world into two attitudes or orientations. The first is expressed by the very personal I-You or I-Thou attitude, which establishes the world of relation as opposed to the world of experience. The world of relation is unmediated, direct, and nonconceptual—like Zen.

The second way of looking at the world is expressed by the I-It orientation—the world as experience. To Buber, the world of experience is the domain of science. It is impersonal, indirect, and remote. In the world of science, anything can be reduced to a set of numbers; anything can be categorized, classified, abstracted, digitized, and dealt with impersonally—including people. For Buber, I-He or I-She is the same as I-It: people are treated and experienced as impersonal objects.

How does Buber's division of the world into these two attitudes help us learn how to see and how to be? How does it help us experience the creative process? How does it relate to experiencing Zen and satori? I believe that Buber answered these questions in his book; he related what I interpret as an experience of enlightenment or satori realized by his I-You or I-Thou orientation to the world as applied to an inanimate object. He told of a walk he took one dim morning and his discovery of a piece of mica lying on the road. After picking it up and looking at it for some time, he found that his day was brightened by the light caught by the stone. Then for a moment, he looked away and suddenly realized that while looking at the mica, the thought of "object" and "subject" had never entered his mind. He and the mica had been one. While looking at this inanimate object, he had tasted unity with it. He looked back at the mica, but the sense of unity was no longer there. Then, as Buber relates it, something creative flamed up inside him: *"I closed my eyes, I concentrated my strength, I entered into an association with my object, I raised the piece of mica into the realm of that which has being"*.

Buber's I-Thou attitude toward the world and his moment of satori are echoed in the words of photographer Ernst Haas:

"...you're all free, just let it be, let it become, and with tremendous compassion towards everything — maybe human beings, or nature, or objects — you incorporate. It's almost like a... in Buddhism, you would say incarnation. You become things, you become an atmosphere.

And if you become it, which means you incorporate it within you, you can also give it back. You can put this feeling into a picture."

Conclusion

In closing, let me summarize the interactive and interconnected parts of the process described in Part I: the experiencing of Zen through photography and photography through Zen.

1. Open yourself to the light, images, and reality around you. At first you need to *consciously* create a heightened state of awareness where the mind is open, receptive, and actively looking for images. The more you actively look, the more the action will become intuitive and natural, subconscious and effortless. With practice, your eye will be intuitively and subconsciously drawn to the light, and the light will be drawn to your eye. You will react to the light. You will feel the light. You will concentrate your focus on the light. And, you will find that your normal, everyday state of mind has become an open, aware, and receptive state.

2. Open yourself to feeling—look with your capacity to feel—and you will experience and become part of the Now, Reality, Being; the isness of the moment. Always follow your feelings, whether you are capturing one image per hour or seven images per second.

3. Experiencing real moments will lead you to a culminating moment of satori—a moment when you hear the light; the image sings; and form, content, and feeling are one. Joel Meyerowitz expressed it this way: "You should be totally enraptured... by the experience itself...It's about passage of the experience itself, in its wholeness, through you, back into the world, selected out by your native instincts".

Manuel Alvarez Bravo summarized the experience of capturing real moments even more succinctly: "It goes in through my eye, and out through my camera".

4. Lastly, no matter which medium you choose—still photography, videography, cinematography, haiku, calligraphy, acting, singing, dance, music, painting, surfing, archery, or tennis—you will, by virtue of being in the moment, improve the quality of your art. I have found that if I open myself to the light and images around me; if I look with my capacity to feel; if I approach both the animate and the inanimate worlds with the I-Thou attitude; if I maintain a blank, empty, but sensitized mind (the "mind of no-mind", placed nowhere but everywhere, like the moon in water); then I am able to see more, to feel more, and to be more. As a photographer, I can capture more of

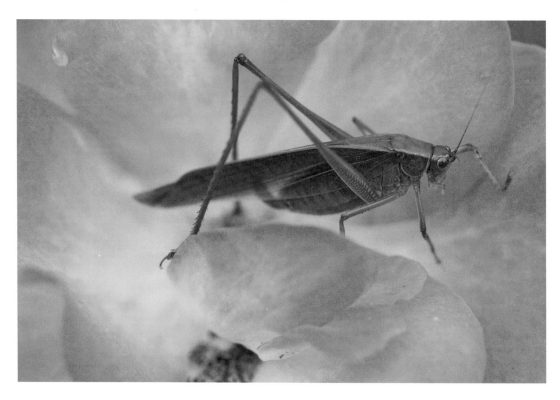

▲ *Grasshopper and Rose. Los Angeles.*
"And sometimes I did see what man has only glimpsed." Arthur Rimbaud

the invisible images around me. By being in the moment I can experience photography through Zen, and conversely, Zen through photography. It makes me a better photographer, opens me to real moments, and eliminates artificial distinctions between seeing, being, and photography. They become one and the same thing.

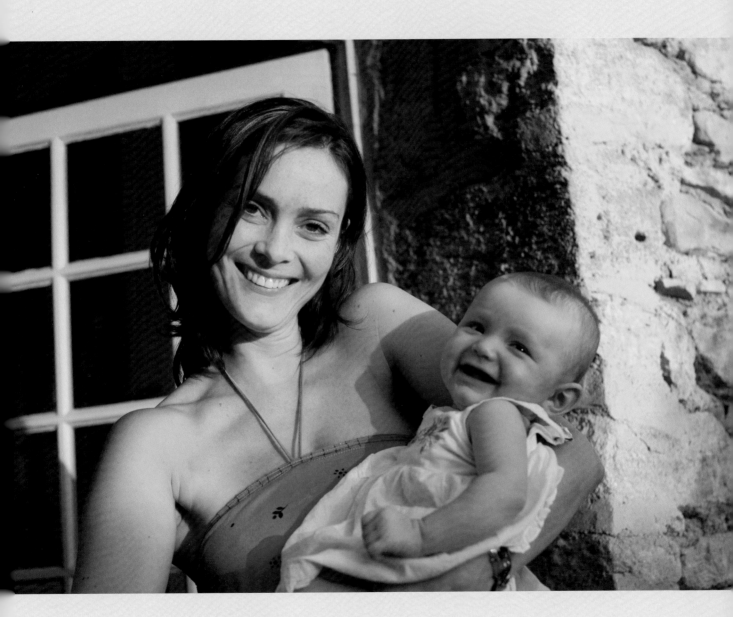

▲ *Joie de Vivre. Ansouis, France*

Opening Oneself to the Photographic Image in All its Forms: From the Still Photograph to the Motion Picture

Photography is the literature of light; the cinematographer is a writer who utilizes light, shadow, tonality and color, tempered with his experience, sensitivity, intelligence and emotion to imprint his own style and personality on a given work...
Vittorio Storaro, Director of Photography

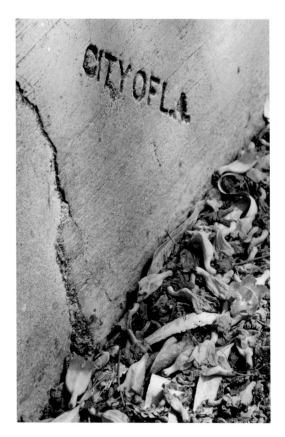

▲ *City of L.A., Los Angeles*

We have moved from a word-based to an image-based society; from Gutenberg to Google. This book is focused on the art of seeing and improving the quality of photographic images by developing visual awareness, sensitivity, and intuition. In this section we will examine a few concepts that apply to the photographic image—to seeing—in all its forms: from the still photograph, to the photo essay, to the motion picture.

All forms of photographic images are interrelated. They are all capable of animating us and, in turn, of being animated by us. They contain points of punctuation, or punctum, which are capable of provoking satori. All forms of the photographic image are interconnected: what we learn from one applies to the others. They are all about seeing, and ultimately, about being.

Extending the Concept of Punctum:
From the Still Photograph to the Motion Picture

In Part I, we presented Roland Barthes' definition of photography. To reiterate, he described the photographs that animated him, and that he in turn animated, as consisting of two co-present elements—studium and punctum:

- The element of studium comprises the cultural, representational, and informational content of the photograph.
- The second element, punctum, breaks (or punctuates) the studium.

Punctum rises out of the scene, seeks out the viewer, disturbs the studium, wounds, pricks, cuts, and stings the viewer. As Barthes put it, "A photograph's punctum is that accident which pricks me (but also bruises me, is poignant to me)".

Punctum is very often a detail. Barthes found that he could be touched by a photograph if he disregarded what had been said about it, said nothing, shut his eyes, and allowed the details to rise of their own accord into his affective consciousness. Most importantly, Barthes observed that punctum had the power to expand, to provoke satori. In Part I, we applied Barthes' definition of photography to Dennis Stock's photograph of James Dean in Times Square. I spoke of the punctum (the points of punctuation) which provoked satori in me.

As in the still photograph, a detail within a motion picture scene can similarly provoke satori within the viewer in an interactive, reciprocal way. This detail may originate in an actor's intuition, in an improvised moment, or in a moment of satori that reveals the actor's significant intuitions into reality.

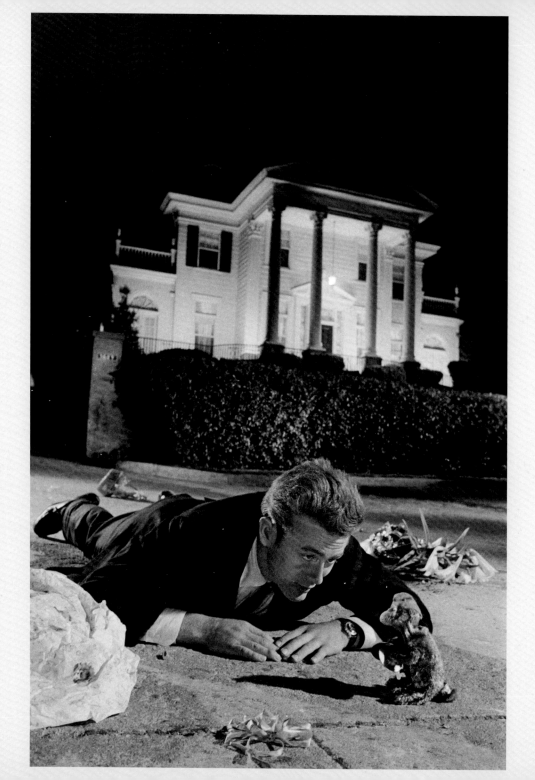

Rebel Without a Cause

For example, during the opening credits of *Rebel Without a Cause* (1955), we see a drunken James Dean being attracted to a cymbal-playing, wind-up toy monkey on the ground in front of him. He falls to the ground and becomes dismayed when the monkey stops moving. He taps it with his finger and tries to speak to it. After getting no response he turns it around and winds it up again. He happily watches the moving monkey and then lovingly clasps it with both hands and lays it down, covers it with some wrapping paper, and puts some gold ribbon near the top of its head. He then curls up next to it in the fetal position, adjusts the paper blanket on the monkey, puts one hand between his legs and the other under his chin, and goes to sleep alongside the toy.

This improvised, spontaneous sequence was filmed at Dean's insistence at the end of an exhausting 23-hour workday. For me, one source of the punctum in this satori-provoking scene is the attitude of James Dean towards the abandoned toy monkey. I find that his attitude is poignant and I am touched by it. It's an attitude that breaks or punctuates the studium of the scene and provokes satori. It is clearly not an I-It attitude. In the spirit of Buber's I-Thou relationship,

Dean raises the inanimate toy monkey "into the realm of that which has being". He animates the inanimate; the monkey ceases to be an It; he tames the toy monkey. In particular, the way he playfully grabs the toy with both hands is reminiscent of the way one would behave with a family pet.

In the spirit of the I-Thou attitude toward life, Dean is drawn into a relation of the heart with the toy monkey just as the Little Prince is drawn into a similar relation with his rose in Antoine de Saint-Exupéry's classic story *The Little Prince* ("It is only with the heart that one can see rightly; what is essential is invisible to the eye"). In this story, the Little Prince tames a rose and learns that "you become responsible, forever, for what you have tamed. You are responsible for your rose..." In this scene, we see James Dean taming and becoming responsible for the toy monkey. *The Little Prince* was Dean's favorite book.

Another source of punctum in this opening scene is the actor's intuitive action of curling into the fetal position beside the monkey. This improvised action arose out of the scene, disturbed the studium, and provoked satori. James Dean was experiencing a "real moment".

◄ *James Dean. Opening Scene, Rebel Without a Cause, 1955. © Dennis Stock/Magnum Photos*

A second example of Zen in action in *Rebel Without a Cause* is the final scene of the film ("I've got the bullets"). After forming a small family with Jim (James Dean) and Judy (Natalie Wood) at the deserted mansion, Plato (Sal Mineo) awakens from a nap to find himself surrounded by gang members in pursuit of Jim. Feeling abandoned, Plato escapes the gang only to find himself pursued by the police investigating a possible break-in at the mansion. Terrified and armed, Plato takes refuge in the nearby Griffith Park Observatory and is quickly joined there by Jim and Judy. Jim talks a reluctant Plato into momentarily giving up his weapon. After secretly removing the ammunition clip, Jim returns the gun to Plato. With the police outside, Jim convinces Plato to surrender. However, when a nervous Plato appears at the front door of the Observatory, the police turn on all their lights, blinding and frightening him. Gun in hand, Plato runs for it and the police open fire. After Plato is hit, Jim holds up the ammo clip and screams at the police: "I've got the bullets! Looooook!"

What we see next are the improvised and empathic movements of Dean who, in his grief, struggles to drag himself and his almost lifeless legs around the dead body of Plato as if he, too—in total identification with his young friend—were paralyzed by the same bullet. Then, after straightening out the folded leg of Plato he starts to giggle at Plato's mismatched red and blue socks, echoing back to happier times at the abandoned mansion. Jim then breaks down, grabs his father's legs, and begs him, "Help me". The last of Dean's improvised actions in this scene is zipping up his red windbreaker on the dead body of Plato ("He's always cold"). This gesture brings us back 24 hours earlier to the moment when Jim offered his jacket to Plato upon their initial meeting in the police station.

These intuited and improvised actions serve to close the 24-hour circle of the story. They were intuited by Dean through affective consciousness as he struggled through repeated takes for a way to make this final scene a truthful and real moment. According to *Rebel's* director Nicholas Ray, "... Dean was a brilliant actor. His imagination was fresh as a new day". By opening himself to the truth of the moment and to the poetry of the instant, Dean found the punctum and experienced satori. In the same way, we, as viewers of the film, experience the truthfulness and reality and satori of that moment.

Another incident that occurred in *Rebel Without a Cause*—during the filming of the famous knife fight sequence at Griffith Park Observatory—illustrates the acting philosophy shared by James Dean and

Marlon Brando, as well as its relationship to the Zen orientation of this book and to our life as photographers.

During one intense retake of this fight that had not gone well at first, Corey Allen cut Dean on the ear. Seeing the blood, director Nicholas Ray stopped the action. At that point, Dean blew up and started yelling at Ray, "What the hell are you doing? Can't you see I'm having a *real* moment? Don't you *ever* cut a scene while I'm having a real moment! What the f—k do you think I'm here for?"

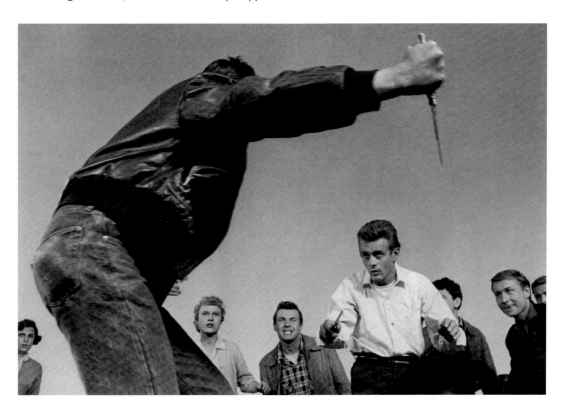

▲ *James Dean. Knife Fight Scene, Rebel Without a Cause, 1955. © Dennis Stock/Magnum Photos*

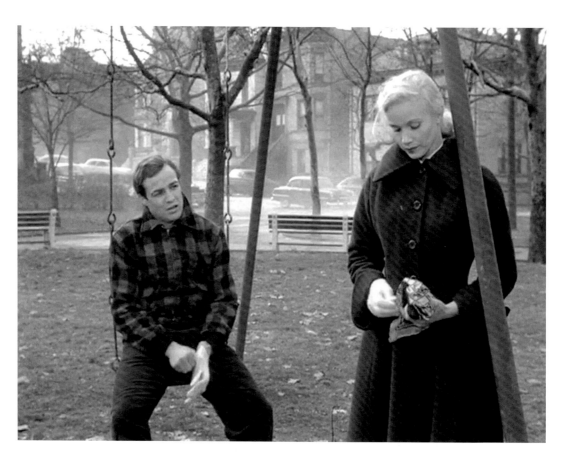

▲ *Marlon Brando and Eva Marie Saint. Glove
Scene, On the Waterfront, 1954. © Columbia
Pictures Corporation*

On the Waterfront

Both James Dean and Marlon Brando were known for their intuitive, spontaneous, realistic, and "in the moment" style of acting, popularly known as "The Method". In the filming of *On the Waterfront* (1954), during a rehearsal of the scene in the park between Marlon Brando and Eva Marie Saint, Saint accidentally dropped one of her white gloves. In Saint's words, "Most actors would have picked it up and put it in my hand. [Brando] put it on his hand and kept doing the scene. I had to stay there to get the glove back". This moment of satori was mentioned by Kazan in his autobiography: "I've been praised for the scene in which, as they walk, Edie drops her glove and Terry picks it up and, when she reaches for it, doesn't give it to her but draws it on his hand. I didn't direct that; it happened, just as it might have in an improvisation at the Actors Studio".

Only by being absolutely in the moment was Brando able to react so intuitively to the unfolding reality. His reaction brings to mind the absolute absorption with the Now, with "real moments", with seeing and feeling, that you as a photographer need to experience in order to produce your best images.

You must be visually open, aware, and in the moment. This is the very same state of awareness that produced Basho's experience of Zen and satori as expressed in his celebrated haiku:

The old pond.
 A frog jumps in —
 Plop!

Motion picture scenes that contain intuitive, improvised moments, like the glove scene with Marlon Brando, can trace their origin and inspiration back to the Zen concept of the "everyday mind". Thomas Merton in his book *Zen and the Birds of Appetite* illustrates what is meant by the everyday mind:

A Zen Master was once asked:
 Q. What is Tao? (We may take Tao as
 meaning the ultimate truth or reality.)
 A. It is one's everyday mind.
 Q. What is one's everyday mind?
 A. When you are tired, you sleep;
 when hungry, you eat.

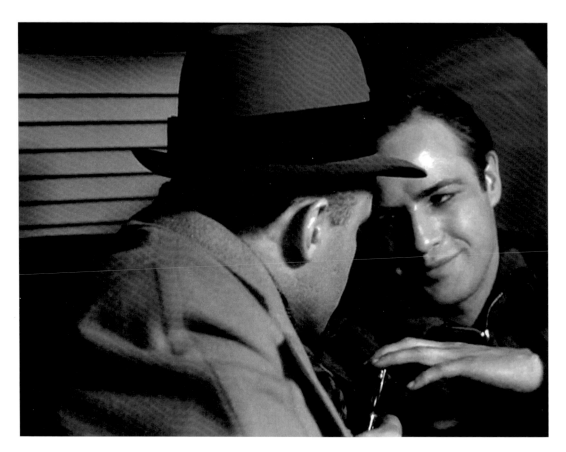

▲ *Marlon Brando and Rod Steiger. Taxicab Scene,*
On the Waterfront, 1954. © Columbia Pictures
Corporation

The everyday mind is a state free of conscious deliberation and thought: it is sleeping when tired and eating when hungry. It has been said that Zen is the everyday mind. Marlon Brando's ability to exist in, and to draw creatively from, the everyday mind—his ability *to be*, to become, to exist in the reality of the moment, to find the truth of the moment, to find the satori-provoking punctum that "rises out of the scene, seeks out the viewer, disturbs the studium, wounds, pricks, and stings the viewer" helped him to create his iconic acting performances.

Brando's astonishing connection to the everyday mind is seen again in the famous taxicab scene in *On the Waterfront*. After Charley (Rod Steiger) fails to convince his younger brother Terry (Marlon Brando) to take a job offered by the mob and not to testify against them, Charley explodes and pulls a revolver out of his coat pocket. He points it at Terry, and commands him to take the job: "Listen, to me, Terry! Take the job! Just take it! No questions! Take it!" What happened next is another example of working from the "everyday mind" with its "significant intuitions into reality". Upon seeing the gun, Brando reacts with a series of incredulous "Wha... Wha....WhaCharley,... Chaaarly..." Then continuing to shake his head in disbelief from side-to-side, he reaches for the barrel of the revolver with, as Director Elia Kazan put it, "the gentleness of a caress", looks his brother straight in the eye, and slowly lowers the weapon, while once again uttering "Charley... oooooh, Chaaaarley............Wow".

This gesture, coupled with the painfully felt sounds of "Oh, Charlie!" sprang from the everyday mind, from being into the Now, from being "so much in the scene", as Kazan described it in his book *Elia Kazan: A Life*. In discussing Brando's iconic performance, Kazan refused to take credit for the direction of the scene: "I didn't direct that; Marlon showed me, as he often did, how the scene should be performed. I could never have told him how to do that scene as well as he did it". Brando's intuitive action gives truth to the observation of the French poet Baudelaire when he spoke of "the emphatic truth of gesture in the important moments of life". In this case, we have gesture surrounded by sound that creates points of punctuation, or punctum, which in turn, provoke satori in the viewer.

Perhaps the most famous of the interactions that took place between Brando and Steiger is the "I coulda been a contender" sequence that follows the "Charley.....oooooh, Chaaaarley...............Wow" utterance of Brando:

Steiger: Look, kid...I...Look, kid...I. How much do you weigh, son? When you weighed 168 pounds you were beautiful. You could have been another Billy Conn. That skunk we got you for a manager, he brought you along too fast.

Brando: It wasn't him, Charley. It was you. *You remember that night in the Garden you came down in my dressing room and said "Kid, this ain't your night. We're going for the price on Wilson." You remember that? "This ain't your night!" My* night. *I coulda taken Wilson apart. So what happens, he gets the title shot outdoors in the ballpark and what do I get, a one-way ticket to Palookaville. You was my brother, Charley. You shoulda looked out for me a little bit. You shoulda taken care of me just a little bit so I wouldn't have to take them dives for the short end money.*

Steiger: Oh, I had some bets down for you. You saw some money.
Brando: You don't understand! I coulda had class. *I coulda been a* contender. *I coulda been* somebody. *Instead of a* bum...*which is what I am. Let's face it............It was* you, *Charley.*

In the book *Conversations with Brando*, Brando linked the truthfulness and the reality that he felt at that moment—and that, in turn, was felt (and given back) by the audience—to the concept of the every-day mind:

You have to be able to give something back in order to get something from it. ... Everybody feels like they could have been a contender, they could have been somebody... that they could have done better, they could have been better. Everybody feels a sense of loss about something. So that was what touched people. It wasn't the scene itself.

Earlier in this book, Roland Barthes stated that still photographs that "animated" him and that he, in turn, "animated" consisted of both studium and punctum, and that punctum had the power to provoke a satori. The taxicab scene in *On the Waterfront*

illustrates how these concepts may be applied to motion pictures. Watching this scene, we are animated by Marlon Brando's acting and by the points of punctuation, or punctum. In turn, we "*give* something back"; we animate Brando's performance and share in the reciprocal experience of Zen and satori.

It seems clear at this point that if, in the course of everyday living, you connect with and draw from the everyday mind, whether as an actor, a photographer, or a human being, you will experience Zen and satori. You will have significant intuitions into reality. You will experience the isness and the truth of the moment. If you experience seeing, feeling, and being at an intuitive level as a photographer while in the act of discovering, creating, and capturing images, then the quality of your images will improve. Experiencing Zen through photography and photography through Zen will help you produce your best images.

In Cold Blood

Like Brando and Dean, Director of Photography Conrad Hall experienced Zen and satori while filming one of the final scenes of *In Cold Blood* (1967). The element of studium in the scene involved an about-to-be-hanged murderer (Robert Blake) reminiscing about his father. The satori was provoked by an unexpected detail that disturbed, broke, and punctuated the studium. It was this element of punctum, this point of punctuation, rising out of the scene and wounding Hall, that provoked a satori in him and produced a stunning emotional effect on the viewer. The May 2003 issue of *American Cinematographer* relates what happened in Hall's own words:

"It was raining the night the two killers were hung. The warehouse where they were hanged and Death Row were two locations in which we weren't allowed to shoot, so we had to recreate them. I wound up lighting this scene of a man about to be hanged, talking to a chaplain as rain was being created outside the window. The light from the prison yard was creating a dim, moody ambiance, and the chaplain was reading from the Bible by the light of a little desk lamp. The outside light was creating the penetration, and we used a wind machine to create some movement in the rain. But the machine blew a mist on the windowpanes, and after a certain point the mist became so heavy that it started to trail down. While I was lighting the scene, I noticed that the light from outside was shining through the water

sliding down the windowpane and projecting a pat-
tern resembling tears on the face of Robert Blake's
stand-in. I brought it to Richard's attention (Director
Richard Brooks). In the finished scene, the acting,
cinematography, direction and writing all come
together to create a very memorable moment.
People think you're a genius for planning something
like that, when in reality you were just smart enough
to notice it and exploit it."

Granted, the appearance of tears running down
Robert Blake's face caused by condensed mist sliding
down the windowpane was accidental—but Conrad
Hall *saw* it. By letting the details in the scene rise of
their own accord into his affective consciousness,
Conrad Hall was moved, touched, stung, pricked,
wounded, and cut by the many points of punctuation.
The studium of the scene was disturbed, broken,
and punctuated by the punctum. As Barthes would
have described it, the punctum rising from the
scene, shooting out of it like an arrow, pierced
Conrad Hall.

▶ *The Original Pantry. Los Angeles*

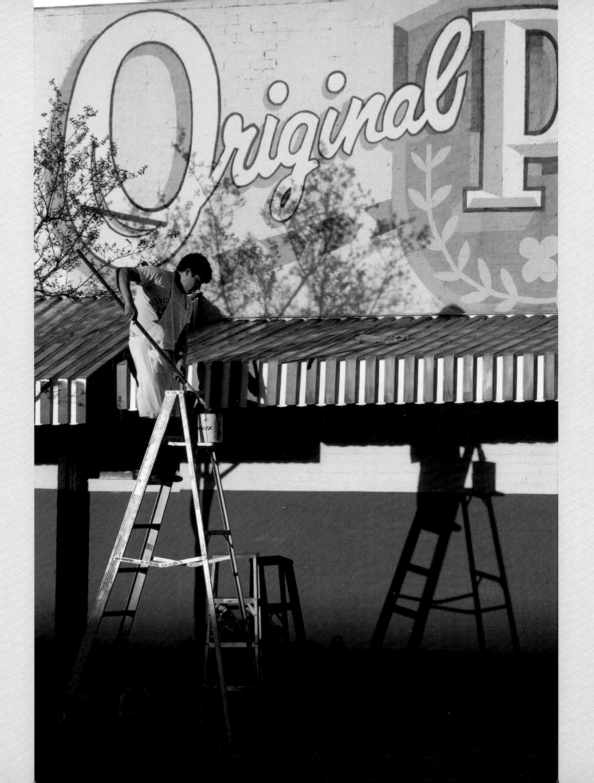

Exploring the Concept of The Third Effect:
From the Still Photograph to the Motion Picture

The Still Photograph and the Third Effect

The phenomenon known as the Third Effect occurs in a still photograph whenever its elements combine to suggest a deeper ironic meaning or a meaning richer than the sum of the individual visual elements, or $1 + 1 = 3$. With this in mind, let's examine Arthur Rothstein's photograph titled "Gee's Bend" and look for the Third Effect: look closely and "allow the detail to rise of its own accord into affective consciousness".

In Rothstein's photo, a young black girl looks out the window of a log cabin. The newspaper that covers the inside of the wooden shutter shows a white, middle-class woman with some freshly baked goods; the headline proclaims, "Your Baker Offers You a Tempting Variety". In his book *Documentary Photography*, Rothstein explained the photo in the following way: "What makes this a special picture is that it combines graphic symbols—such as the advertisement—with other elements in the photograph to create a third effect. You see the girl—that's effect one. You see the ad—that's effect number two. But the third effect is when you see both images together and recognize the irony".

Roland Barthes spoke of this effect as "the co-presence of two discontinuous elements". In this case, the two discontinuous elements are the poor black girl juxtaposed to the middle-class white woman with her "tempting variety" of baked goods. Furthermore, if you carefully examine all the details in the photograph, you will find that it is filled with many points of punctuation, or punctum. For example, if you turn the photo upside down, you see an advertisement for shredded wheat. The ad shows a white man pushing a white woman on a swing while saying, "You sail high when you start the day with shredded wheat!" Look for other points of punctuation. Then go back to Sebastião Salgado's photograph in Part I and describe the visual elements found within that photograph that create the Third Effect.

▶ *Gee's Bend, Alabama (Artelia Bendolph), 1937.*
© Arthur Rothstein/Library of Congress

50

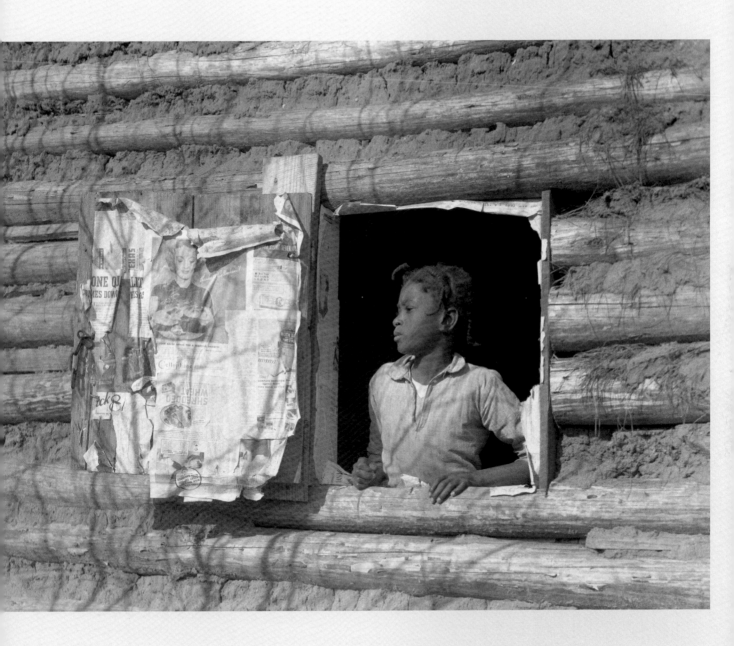

The Third Effect is also at work in the following photograph taken in Milan, Italy by *National Geographic* photographer George Steinmetz.

Study this photo carefully and identify the studium, the punctum (the "points of punctuation"), and the elements contributing to the Third Effect. I found one satori-provoking "point of punctuation" in the following detail: the elements of the logo on the plastic bag carried by the running young woman (a skull on top of a cross) are also present in the portrait of the crucified Christ just above her. Another point of punctuation—a detail that wounds, disturbs, and adds to the Third Effect—is the hole in the glass door protecting the painting of Christ. The hole appears to have been made by a rock, a bullet, or another flying object and creates a pattern of lines that radiate out from the hole—like the golden rays of light, the halo, radiating from the head of Christ. Applying the vocabulary of Arthur Rothstein: "You see the pierced flesh of Christ—that's effect number one. You see the hole in the glass—that's effect number two. But the third effect is when you see both images together and recognize the irony".

All of these points of punctuation are capable of provoking satori, and they all contribute to producing the $1 + 1 = 3$ effect. In addition, as you look closely at this photo, consider whether there is any meaning or symbolism in the fact that the running young girl, the poster of the woman holding her breasts, and the portrait of Jesus form a triangle. Open yourself fully to this image and let the details rise of their own accord into your affective consciousness. Make visible more of the invisible elements locked in this decisive moment.

Then, to see the visual equivalent of this still photo in a motion picture, watch the opening three minutes of Federico Fellini's *La Dolce Vita* (1960). Film Critic Richard Schickel considers the opening shots of this film as "one of the most famous sequences in modern cinema". As the film opens, a helicopter carries a statue of Christ with outstretched arms; the helicopter flies over an ancient Roman aqueduct, modern low-cost apartment buildings, streets filled with children chasing the shadow of the flying Jesus, and finally over a group of beautiful, sexy young women sunbathing on the rooftop terrace of a luxury apartment building. A second helicopter carrying a journalist and a photographer hovers over

▶ *Street Scene. Milan, Italy, 1992.*
© George Steinmetz

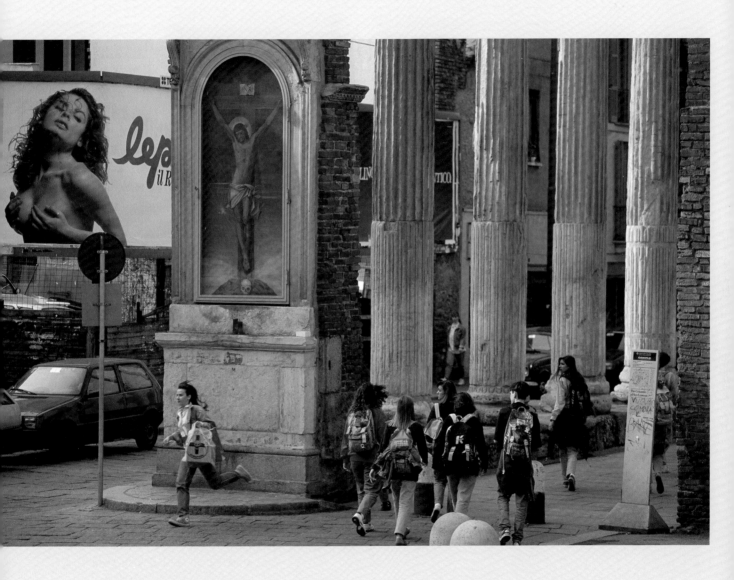

the women while the two men flirt suggestively with them and try to get their telephone numbers. This sequence contains many of the same visual elements found in the still photo taken by George Steinmetz: the contrasts between ancient and modern, spiritual and sexual, sacred and profane, pure and carnal. As Rothstein put it, "The Third Effect is when you see both images together and recognize the irony". In a motion picture, it's when you see the different scenes and cuts together and recognize the irony.

The Photo Essay and the Third Effect

A photo essay consists of a group of photographs shot, selected, and arranged to tell a story. The individual photos and their arrangement on the printed page can create the Third Effect. W. Eugene Smith, the "Shakespeare of Photojournalism", understood the power of a single photograph as well as the impact made by the interaction between photographs in a photo essay: "When there are two or more images on a page, all images will be experienced simultaneously, even if the viewer is focusing only on one. And there are subliminal statements that will appear between the pictures actually reproduced, in a sense growing out of each other and making an

impression beyond each single image". A fine example of this phenomenon is found on the double-page spread titled "He Must Specialize in a Dozen Fields" taken from "Country Doctor", one of Smith's most famous *Life Magazine* photo essays. In speaking about the design of this double-page spread, Maitland Edey, former assistant managing editor at *Life*, praised the designers for the "burst of memorable pictures" and for the "great range of sensations and emotions powerfully compressed into a single spread".

Viewing this two-page spread by W. Eugene Smith, you can feel how the interaction between the photographs has a greater effect than the individual sum of all the photographs viewed as separate statements. Individual photos (1 + 1), "powerfully compressed into a single spread" when "uncompressed" and mutually interactive on both a conscious and a subliminal level, produce the Third Effect (= 3). Smith's reference to "subliminal statements that will appear between the pictures actually reproduced, in a sense growing out of each other and making an impression beyond each single image" is analogous to what great motion picture editors are able to achieve by selecting, arranging, and timing the shots of an unedited film.

▶ *Country Doctor. Life Magazine, 1948.*
© *W. Eugene Smith/Time & Life Pictures/Getty Images*

HE MUST SPECIALIZE IN A DOZEN FIELDS

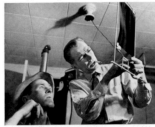

HOME CALL at 8:30 a.m. starts Ceriani's day. He prefers to treat patients during office hours at the hospital, but because this printer had a fever and symptoms of influenza Ceriani thought it would be unwise for him to get up and make the trip.

MINOR EMERGENCY disrupts Ceriani's office routine. This 60-year-old tourist, suffering from a heart disturbance aggravated by a trip through an 11,000-foot pass in the Rockies, came to the hospital to get an injection of morphine.

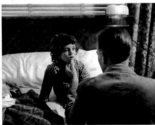

ANOTHER HOME CALL turns up a feverish 4-year-old suffering from acute tonsillitis. Although a large proportion of his patients are children, Dr. Ceriani is still inexperienced in pediatrics and studies it whenever he has an opportunity.

THE DAY'S FIRST OFFICE CALL is made by a tourist guide and his baby, who have come to Kremmling from an outlying ranch. Ceriani's patients are of all ages and income groups and come from doctorless areas as far as 50 miles away.

X-RAY PICTURE is explained to a rancher by Ceriani, who developed the negative himself. In addition to the X-ray machine, the hospital contains about $10,000 worth of equipment, including a $1,500 autoclave and an oxygen tent.

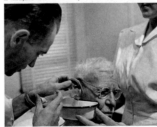

BROKEN RIBS, the result of an accident in which a horse rolled on this patient, are bound with adhesive tape by Ceriani. Many of his hardy patients walk in with injuries which would make city dwellers call at once for an ambulance.

PROBLEMS OF AGE—in this case a slight deafness complicated by deposits of ear wax—are daily brought to the doctor. Here, in an operation chiefly important for its effect on the patient's morale, Ceriani removes the wax with a syringe.

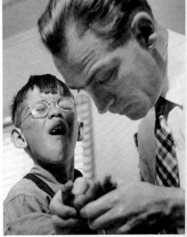

WOES OF YOUTH fill Ceriani's office with noise. Above: he examines stitches in the lacerated hand of a squalling 7-year-old. Below: he uses a rubber tube to remove the mucous which clogs the throat of an infant he has just delivered.

CONTINUED ON NEXT PAGE

116

117

55

The Motion Picture and the Third Effect

A sophisticated and powerful example of the Third Effect in motion pictures is the baptism scene in Francis Ford Coppola's *The Godfather Part I* (1972). The "third effect" is achieved through superlative editing of image and sound; through the seamless juxtaposing and interweaving of contrasting symbols, sounds and actions; and through the use of artistic cross-cutting. For example, at the beginning of the baptism ceremony, the parents of the baby untangle and remove the baby's bonnet with hand gestures that are similar to those seen in the following juxtaposed scene, where one of the hit men of the Corleone family reaches for an automatic weapon in preparation for the slaying of the heads of the other mafia families. In another church scene, after the priest touches salt to the mouth and chin of the infant, Coppola cuts to a barber dispensing shaving cream into his hand and putting it on the face of another one of the hit men waiting for the appointed hour. Brilliant cross-cutting. In the middle of the baptism ceremony, the priest asks Michael Corleone, godfather of the infant, if he believes in God and Jesus Christ ("I do"). Coppola then cuts to scenes of the Corleone hit men moving into action from their different locations.

Interlaced with shots from the church and the priest asking Michael Corleone if he believes in the Holy Ghost and the Holy Catholic Church ("I do"), if he renounces Satan ("I do renounce him"), and all his works ("I do renounce them"), Coppola cross-cuts to the murders of the heads of other mafia families. At the culmination of the murders, the priest asks Corleone if he would be baptized and he responds, "I will". As the holy water is poured upon the head of the child, we cut to several of the murder scenes and see traces of running blood. The juxtaposition of these scenes, coupled with a sound track in full opposition to the visuals (Latin liturgy with organ backing), produce a powerful $1 + 1 = 3$ effect. Furthermore, the contrasting details in each juxtaposed scene provide points of punctuation, or punctum, capable of expanding, interacting, and provoking satori.

Conclusion

Part II of *Zen and the Magic of Photography* has stressed the interconnections between three forms of the photographic image: the still photograph, the photo essay, and the motion picture. It has examined how they share the concepts of studium, punctum, satori, and the Third Effect. Other shared concepts and techniques are found in the fields of lighting, editing, and composition.

Today, the still photograph, the photo essay, and the motion picture have more in common than ever before. The most recent convergence of these disciplines can be seen in the appearance of professional DSLR cameras that are capable of shooting high-definition video. This is a revolutionary technological and conceptual advancement in the history of the photographic image.

▲ *The Colors of Provence. Roussillon, France*

Opening Oneself to the Light:
Some Personal Moments of Experiencing
Zen and Satori through Photography

Mistral-whipped summer light.
Luminous stars, blue-black night.
Midi magic.
Wayne Rowe

"Whether you're making images, poetry, painting, music, or love, you should be totally enraptured by that, by the experience itself. That's what it is about—the location of subject, it's about passage of the experience itself, in its wholeness, through you, back into the world, selected out by your native instincts."
Joel Meyerowitz, Cape Light

Some Personal Moments of Satori

I discovered or created the photographs in Part III while actively looking with my capacity for feeling. Whether I happened upon my subjects by accident or composed and lit them carefully in a studio or on location, I was always intensely searching for images and actively open to receive the light. Always guided by my feelings, I recorded the images when they felt right through the viewfinder of the camera. Unknowingly, I was experiencing Zen through photography and photography through Zen. Once in this creative state—the Now, the isness, the reality of the moment—I was able to extend my vision and awareness, become a better photographer, and produce some of my best images.

▶ *Boats. Marais Poitevin, France*

▲ *White Horses. Camargue, France*

◄ *Winter Pears. Venice, Italy*

▲ *Veracruz Dreamer. Veracruz, Mexico*

▲ *Bench. Bellagio, Italy*

When I photographed it with a macro lens, the image titled "Paint Store Trash Bin Lip", which I discovered on a trash bin behind a paint store, reminded me of a boat at sea. Years later, I was able to expand its meaning when I discovered "Le Bateau Ivre" (translated as, "The Drunken Boat") written by the young French rebel poet Arthur Rimbaud. The following excerpt comes from his famous poem and relates events he experienced on a psychedelic journey. What, if anything, does the image suggest to you? Link vision with feeling and allow the details of the photo to rise on their own accord into your affective consciousness. Remember that you will find in the photo what you bring to it. Write down your thoughts and then read the words of Rimbaud that I associated with this image.

Blessed by a tempest, the sea opened to me.
With less weight than a cork, I danced upon the waves
That are called eternal carriers of victims,
Ten nights, never missing the beacon's inane eye.

Sweeter than to children the flesh of sour apples
Green water seeped into the pinewood of my hull
And from the bluish stains of the wine and vomit
Washed me, scattering all, my rudder and boathooks.

And from then on, I have bathed into the Poem
Of the Sea, infused with stars and lactescent,
Devouring green azures where float the drowned
Livid and enchanted, with their eyes wide open.

Where, suddenly tinting the ambient blue, in
Ecstasies and slow rhythms, dazzlement of the day,
Potent as alcohol, much broader than your lyres,
Passion ferments in all its bitter russet tones.

I've seen the skies burst into lightning, water spouts,
Surf and currents. I know evening and also
Dawn soaring forth as in a cosmic flight of doves
AND SOMETIMES I DID SEE WHAT MAN HAS ONLY
GLIMPSED.

I have seen a low sun, stained with mystical horrors,
Bloody the skies with gobs and long purple strata,
And like actors playing in some ancient drama,
Faraway rolling waves striating the distance.

I dreamed the green of night and all its dazzled snows,
A kiss slowly rising to the eyes of the sea,
The coursing of a sap never heard of before
And blooming gold and blue, a phosphorescent song.

Translated from the French by Yvone Lenard
© 2001 (emphasis added)

▶ *Paint Store Trash Bin Lip. Los Angeles, California*

▲ *Fallen Peony Petals. Monet's Garden, Giverny, France*

▲ *Harbor Doors. Vernazza, Italy*

▲ *Young Bacchus. Burgundy, France* ▶ *Country Kitchen Still Life. Provence, France*

Discovering Color Coordination in the Moment

Creating Visual Haikus from the Moment

According to D. T. Suzuki, "Zen discipline consists in attaining enlightenment (or satori)…Satori finds a meaning hitherto hidden in our daily concrete particular experiences…". Waiting for the opening of a stationery store, I was attracted by the outside racks of colorful postcards and calendars, and I started panning the store employees rolling them into place. I was open to the light and images around me and became fully absorbed in the moment. After reviewing the photos, I discovered that the last image in the series was filled with points of punctuation that I had intuitively captured: the Zen calendar at the top of the rack and the Claude Monet Impressionistic calendar near the bottom. These two details provoked a satori in me.

▶ *Postcard and Calendar Display Racks.*
Aix-en-Provence, France

Capturing Color Interactions of the Moment

I am constantly open to light, color, and the interactions between them. The New Lollipop Gelateria added the dimension of taste. Moving closer to the counter to select a flavor or two, my eye was attracted to the mirrored ceiling just above the ice cream counter. In a flash, I was into the moment and was composing my own mix of light, color, and motion—and enjoying it immensely. It felt right. Upon review, this particular image best captured a moment of satori for me. It has a kaleidoscopic mosaic of colors that interact seamlessly throughout the image: ice cream and sorbet colors interact with the bright clothes and surroundings of the expectant customers. The lime green ribbon in the hair of the gelato server, the chartreuse tee shirt of the woman in the upper right corner, and the lime sorbet on the left side of the photo form a triangle. The outstretched arm of the gelato server reaching for a cup connects two of these color elements on the right side of the triangle. One point of punctuation, of punctum, for me was the young woman on crutches. Her broken and fractured image reflects her physical state. But as I look closer, I discover the color interactions of her dress, her bright pink cast, matching painted toenails, and the pink mosaic floor. I see her leaning forward in anticipation and I feel her intense concentration on the gelato. These details or points of punctuation touch and move me. They tell me that she is into the moment and unwilling to put off living to some future date. Despite her present condition, she is going to "pluck the strawberry" and know for herself "how sweet it tasted!"

▶ *New Lollipop Gelateria. San Remo, Italy*

Creating Continuity and Closure in the Moment through the Interaction of Paired Photographs

Graffiti or abstract beauty? When placed side-by-side, two images taken on the same street from different angles created this paired composition reminiscent of the color, shape, and style of works by French sculptor Niki de Saint-Phalle.

▶ *Diptych (inspired by Niki de Saint-Phalle).*
Aix-en-Provence, France

Expanding Your Visual Awareness and Creativity Through Adobe Photoshop

Before getting into digital image capture, I used the "hybrid" method to work in the digital domain. This method consists of film capture, high-resolution film scanning, and intensive image manipulation in Adobe Photoshop. Through the use of Photoshop, I was able to compose, fine-tune, and perfect the digitized image. Photoshop literally allowed me to "paint with light" until the image "sang" on the computer screen: a personal moment of satori. Here I have included several examples of this "hybrid" method of working in the highly creative digital domain.

▲ *Porsche Boxster. Provence, France (Grant Larson, Designer). (35mm scanned film original)*

▲ *Pan-Pacific Auditorium (Welton Beckett, Architect). Los Angeles. (4x5 scanned film original)*

▶ *Pan-Pacific Auditorium. Los Angeles/ Porsche Boxster. Provence, France*

The interior photograph of the restored W. K. Kellogg House in Pomona, California was shot on 4x5 film, scanned at over 2000 ppi, and then color corrected and perfected in Adobe Photoshop. The scene was lit by a combination of electronic flash, daylight, fireplace light, and tungsten sources. Of course, I had to decide how the room would be lit—that is, which lights to use and where to place them. I used my intuition and feelings as a guide, stayed open to the light, made adjustments to the lighting, and waited to "hear the light". I was working from a Zen state of awareness that influenced my photography at every point in the process. When a Polaroid test shot "sang" to me—a moment of satori—I knew intuitively that it was time to put my interpretation of the scene on film. This Zen approach to photography applies whether I am working with sunlight or with studio light.

◀ *Kellogg House Living Room. Pomona, California*

A Few More Magical Moments of Zen, Satori, and Photography

Throughout this book I have urged you to open yourself to the light, images, and reality around you. If you open yourself to feeling and look with your capacity to feel, you will experience and become part of the Now, Reality, Being, the isness of the moment. Always follow your feelings, whether you are capturing one image per hour or seven images per second.

The images on the following five pages (like all of the images in this book) resulted from the merging of Zen and photography.

Page 85 – Burgundy Staircase. Burgundy, France

Page 86 – French Photographer and member of the French Academy, Lucien Clergue and his models. Los Angeles

Page 87 – Love in Provence. Ansouis, France

Page 88 – Waterfront Wall Abstract. Le Vieux Port, Marseille, France

Page 89 – Gondola Reflections. Venice, Italy

lucien clergue
Fifty years of photography
Vintage and recent works

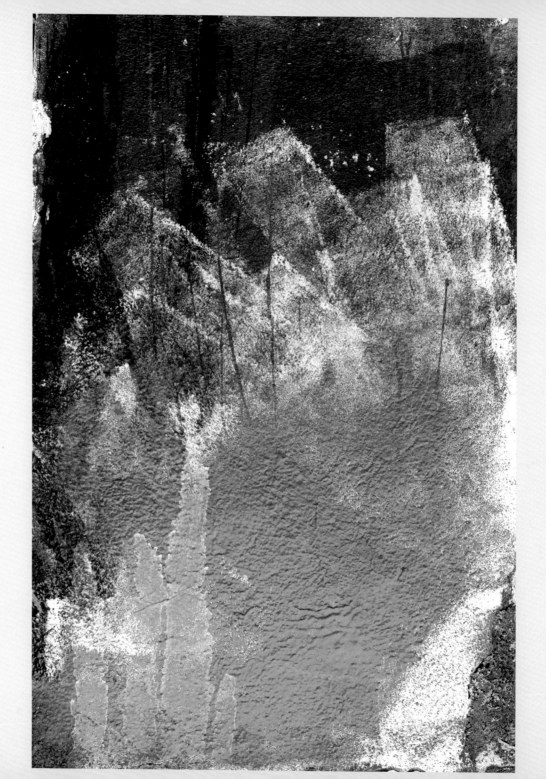

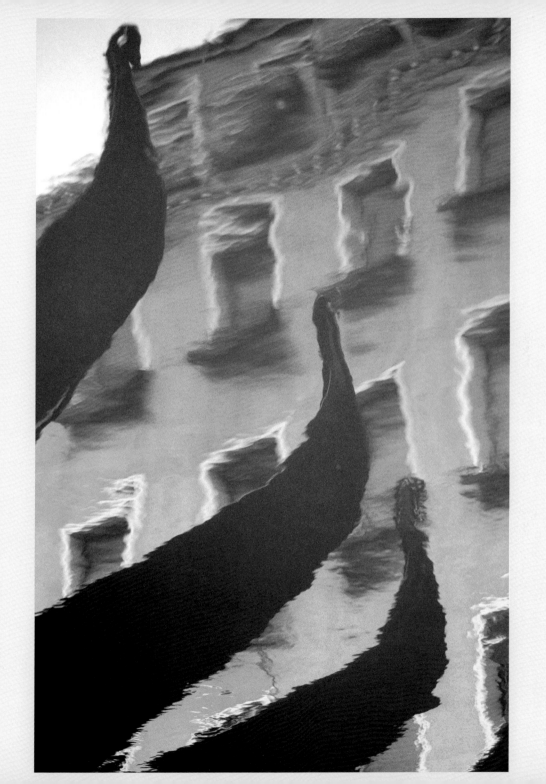

Conclusion

At the beginning of this book, I said that the more you actively look, the more the action will become intuitive and natural, subconscious and effortless; and that with practice, your eye will be intuitively and subconsciously drawn to the light, and the light will be drawn to your eye.

This book is about learning to see and to be—about the *points of intersection and merging* between photography and Zen, between the camera and real moments, between seeing and being—the point at which all such distinctions no longer exist, the point at which photography and Zen are one, the point at which we discover and create our best photographic images.

Of course, we never know when or where photography and Zen will merge and become one. It can happen anywhere and at any time. We must always be open and receptive. One night last summer, I was invited to a neighbor's home for dinner and did not bring my camera with me. While talking with other guests, my eye was drawn to the light coming from the open living room window. Linking vision and feeling, I was into the moment. I immediately saw an image that I knew I had to capture: my neighbor's adopted cat surveying the street from her new home. I quickly borrowed an Apple iPhone and recorded a moment of satori.

▲ *Noirette, the adopted family cat. Ansouis, France*

Bibliography

Adams, Ansel. *Examples: The Making of 40 Photographs.* Boston: Little, Brown and Company, 1983.

Baldwin, Gordon. *Looking at Photographs: A Guide to Technical Terms.* Los Angeles: J. Paul Getty Museum, 1991.

Barrett, Terry. *Criticizing Photographs: An Introduction to Understanding Images.* 3rd ed. Mountain View: Mayfield Publishing Company, 2000.

Barthes, Roland. *Camera Lucida: Reflections on Photography.* New York: Hill and Wang, 1981.

Barthes, Roland. *Image, Music, Text.* New York: Hill and Wang, 1977.

Bayer, Jonathan. *Reading Photographs: Understanding the Aesthetics of Photography.* New York: Pantheon Books, 1977.

Berger, John. "Henri Cartier-Bresson," *Aperture Magazine* 138 (Winter 1995): 12-23.

Blyth, R. H. *Zen in English Literature and Oriental Classics.* Tokyo: The Hokuseido Press, 1942.

Braudy, Leo. *On The Waterfront.* London: British Film Institute, 2005.

Bravo, Manuel. *Manuel Alvarez Bravo: Photographs and Memories.* New York: Aperture, 1997.

Buber, Martin. *I and Thou.* New York: Charles Scribner's Sons, 1970.

Cartier-Bresson, Henri. *The Mind's Eye: Writings on Photography and Photographers.* New York: Aperture, 1999.

Dalton, David. *James Dean: The Mutant King.* Chicago: A Cappella Books, 1974.

Ducasse, Curt John. *The Philosophy of Art.* New York: Dover Publications, Inc., 1966.

Edey, Maitland. *Great Photographic Essays from Life.* Boston: New York Graphic Society, 1978.

Evans, Dean Clarke and Caslin, Jean. *Building a Photographic Library.* Texas Photographic Society, San Antonio, 2001.

Frascella, Lawrence and Weisel, Al. *Live Fast, Die Young: The Wild Ride of Making Rebel Without a Cause.* New York: Touchstone, 2005.

Gallwey, W. Timothy.	*The Inner Game of Tennis.* New York: Random House, 1977.
Green, Jonathan.	*American Photography: A Critical History, 1945 to the Present.* New York: Abrams, 1984.
Greenough, Sarah et al.	*On The Art of Fixing a Shadow: One Hundred and Fifty Years of Photography.* Boston: Bulfinch Press, 1989.
Grobel, Lawrence.	*Conversations with Brando.* New York: Cooper Square Press, 1999.
Haas, Ernst.	*Ernst Haas Color Photography.* New York: Harry N. Abrams, Inc., Publishers, 1989.
Herrigel, Eugen.	*Zen in the Art of Archery.* New York: Vintage Books, 1953.
Langer, Susanne K.	*Problems of Art.* New York: Charles Scribner's Sons, 1957.
Lowell, Ross.	*Matters of Light and Depth: Creating memorable images for video, film, and stills through lighting.* Philadelphia: Broad Street Books, 1992.
Lyons, Nathan (ed.).	*Photographers on Photography.* Englewood Cliffs: Prentice Hall, 1966.
McLuhan, Marshall.	*The Medium is the Massage: An Inventory of Effects.* Corte Madera: Gingko Press, 2001.
McLuhan, Marshall.	*Understanding Media: The Extensions of Man.* Cambridge: MIT Press, 2001.
Meyerowitz, Joel.	*Cape Light: Color Photographs by Joel Meyerowitz.* Boston: Museum of Fine Arts/New York Graphic Society, 1978.
Moore, Sonia.	*The Stanislavski Method: The professional training of an actor.* New York: The Viking Press, 1960.
Newhall, Nancy.	*Edward Weston: The Flame of Recognition.* New York: Aperture, 1975.
Ray, Nicholas.	*I Was Interrupted.* Berkeley: University of California Press, 1993.
Reps, Paul and Sensaki, Nyogen (eds.)	*Zen Flesh, Zen Bones.* Boston: Shambhala Publications, Inc., 1994.
Rothstein, Arthur.	*Documentary Photography.* Boston: Focal Press, 1986.
Saint-Exupéry, Antoine de.	*The Little Prince.* New York: Harcourt, Brace & World, 1943.

Salgado, Sebastião. *An Uncertain Grace*. Aperture/San Francisco Museum of Modern Art, 1990.

Schaefer, Dennis and Salvato, Larry. *Masters of Light: Conversations with Contemporary Cinematographers*. Berkeley: University of California Press, 1984.

Shore, Stephen. *The Nature of Photographs*. Baltimore: The Johns Hopkins University Press, 1998.

Soho, Takuan. *The Unfettered Mind*. New York: Kodansha International, 1986.

Sontag, Susan. *On Photography*. New York: Dell Publishing Co., 1973.

Sontag, Susan. *Regarding the Pain of Others*. New York: Farrar, Straus and Giroux, 2003.

Stanislavski, Constantin. *An Actor Prepares*. New York: Routledge, 1989.

Stanislavski, Constantin. *Building a Character*. New York: Routledge, 1989.

Stephens, Mitchell. *The rise of the image, the fall of the word*. New York: Oxford University Press, 1998.

Stilgoe, John R. *Outside Lies Magic: Regaining History and Awareness in Everyday Places*. New York: Walker and Company, 1998.

Stock, Dennis. *James Dean, 50 Years Ago*. New York: Harry N. Abrams, Inc., Publishers, 2005.

Stock, Dennis and Britton, D. Guyver. *Haiku Journey: Basho's the Narrow Road to the Far North and Selected Haiku*. New York: Kodansha International, 1982.

Stone, Irving (ed.) *Dear Theo: The Autobiography of Vincent Van Gogh*. New York: Signet, 1937.

Storaro, Vittorio. *Writer of Light: The Cinematography of Vittorio Storaro*. Hollywood: ASC Press, 2001.

Suzuki, D. T. *Zen and Japanese Culture*. New York: Princeton University Press, 1959.

Watts, Alan. *The Way of Zen*. New York: Vintage Books, 1989.